A Visual Learning
FOR PARENTS, TEACHERS & KIDS

Diane Bleck

PRACTICE MAKES PERFECT.

AND IT TAKES A LOT OF WORK TO MAKE SOMETHING LOOK SO EASY.

THE BLECK HOUSE
John, Diane, Lillian, Lucy & Jack

Copyright @ 2017 Discovery Doodles, LLC
All rights reserved

Written by: Diane Bleck

ISBN: 1981709746
ISBN-13: 978-1981709748

Table of Contents

Introduction Hi!

Lesson 01 – LINES – – –

Lesson 02 – BASIC SHAPES ○ □ △

Lesson 03 – MIXING SHAPES 🕐 🍊 🐞

Lesson 04 – BULLETS ♀ ☆ ▣

Lesson 05 – BORDERS ℓℓℓ

Lesson 06 – FRAMES ▭

Lesson 07 – PATTERNS ▦

Lesson 08 – ARROWS ⇒

Lesson 09 – LETTERS ABCDE

Lesson 10 – NUMBERS 1 2 3 4

Lesson 11 – FONTS SMALL

Lesson 12 – BANNERSS ▱

Lesson 13 - BUBBLES

Lesson 14 - SIGNS

Lesson 15 - HOW TO DRAW A FACE

Lesson 16 - SHAPES OF FACES

Lesson 17 - EXPRESSIONS

Lesson 18 - HAIRSTYLES

Lesson 19 - PERSONALITY

Lesson 20 - BEAN PEOPLE

Lesson 21 - STAR PEOPLE

Bonus Articles .

About the Artist .

The Doodle Institute

Doodling is Thinking! • 21 Doodle Days • A Visual Learning Workbook

Introduction

I had so much fun creating the Doodling is Thinking! series of Visual Learning Workbooks. The first book, 21 Doodle Days was designed for YOU. It's for parents, teachers and kids who want to learn how doodling is more than drawing.- it is dreaming, discovering and even thinking. I have heard so many people say,

"I DON'T KNOW WHAT TO DRAW. I WISH I HAD A TOOL TO GET ME STARTED."

For 20 years I have been a pioneer for a new industry called Graphic Recording. I got started by filling notebooks with practice pages of lettering, doodles, people, borders, icons and more. Family started to ask to see my journals, friends wanted to see my notes, and clients asked me to draw storyboards, infographics and business models for them. I discovered how to be creative and successful in business.

What you will learn in this workbook is the foundation of Graphic Recording. Which is the art of listening to complex information and simplifying it into thoughtful images for your understanding, and the understanding of others. When you put pen to paper, you open your heart channel to ideas, insights and inspiration, to enter the creative world and listen to the magic language of the universe.

21 Doodle Days will give you a jump-start on your drawing skills and connect you to your own creative portal. This workbook is about building your muscle memory and skills to create simple doodles. And I promise it will pay off, and a flood of creativity will begin to enter your heart and mind.

It is my honor to share this gift with you. Now it is up to you to use it. I suggest that you take the time to go through this workbook with a pen, in order, and practice, practice, practice.

Doodling is Thinking! • 21 Doodle Days • A Visual Learning Workbook

Let's Get Started

Once you know the basics, there are literally hundreds of ways you can apply visual learning from early childhood, elementary and secondary school, and well into your adult life. From infancy to industry, doodling has practical and powerful applications.

Mathematicians and scientists use doodles to explain complex theories and equations. Business people use doodles to map business plans and strategies. Across the globe, people from all walks of life are doodling to help them communicate - to give visual representation and meaning to their ideas, and to help others. Doodles help people innovate.

Doodling has been around forever. Just look at the ancient cave walls and you will see that we, as people, need to communicate using drawings. Doodling connects your hand and mind, which enhances your ability to absorb new information, process it, and remember it later. Doodling can help you unlock your hopes and dreams.

By the end of this workbook, you will be know how to:

- **Draw** the Basic Shapes as well as create a visual vocabulary
- **Add** arrows to your drawings to create maps.
- **Use** patterns, borders and frames to create interest.
- **Understand** how to draw faces and emotions.
- **Create** simple doodles for your personal journal.

ARE YOU READY TO START DOODLING?

Doodling is Thinking! • 21 Doodle Days • A Visual Learning Workbook

LINES

Dot	Line	Dash	Dot & Dash
Wavy	Waves	Bumps	Mountains
Squiggle E	Squiggle E's	Squiggle L's	Squiggle L's & E's
Diagonal	Lightning	Peak	Uh-Oh

Doodling is Thinking! • 21 Doodle Days • A Visual Learning Workbook

LESSON 01

Doodling is Thinking! • 21 Doodle Days • A Visual Learning Workbook

BASIC SHAPES

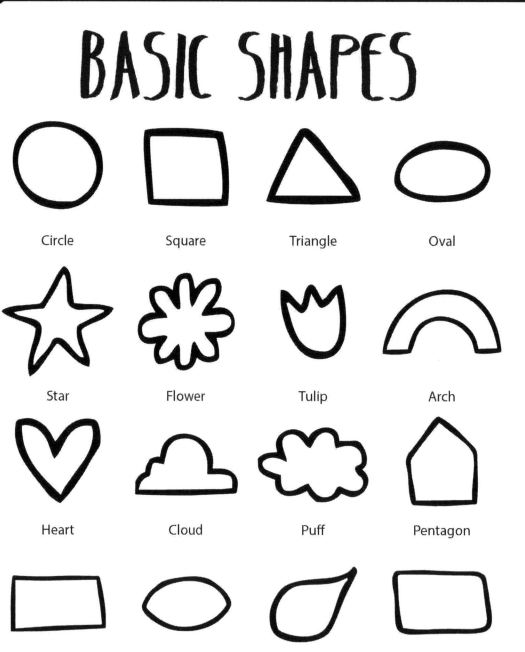

Circle	Square	Triangle	Oval
Star	Flower	Tulip	Arch
Heart	Cloud	Puff	Pentagon
Rectangle	Almond	Tear Drop	Rounded Rectangle

Doodling is Thinking! • 21 Doodle Days • A Visual Learning Workbook

LESSON 02

Doodling is Thinking! • 21 Doodle Days • A Visual Learning Workbook

#21DoodleDays
with Diane Bleck

MIXING SHAPES

Circle	Clock	Orange	Ladybug
Square	Present	Truck	Book
Triangle	Boat	Tent	Tree
Oval	Kitty Cat	Flower	Bee

Doodling is Thinking! • 21 Doodle Days • A Visual Learning Workbook

LESSON 03

Doodling is Thinking! • 21 Doodle Days • A Visual Learning Workbook

BULLETS

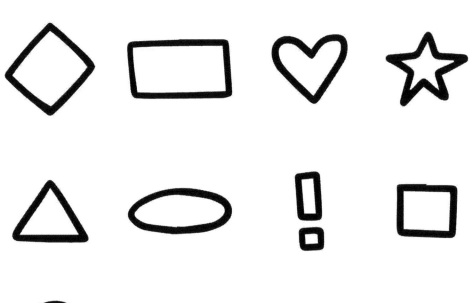

Doodling is Thinking! • 21 Doodle Days • A Visual Learning Workbook

LESSON 04

Doodling is Thinking! • 21 Doodle Days • A Visual Learning Workbook

#21DoodleDays
with Diane Bleck

BORDERS

Squiggles

Leaves

Rainbow Bumps

Bleeps

Rectangles

Circles

Doodling is Thinking! • 21 Doodle Days • A Visual Learning Workbook

LESSON 05

Doodling is Thinking! • 21 Doodle Days • A Visual Learning Workbook

#21DoodleDays
with Diane Bleck

FRAMES

Picture

Scallop

Bleeps

Flowers & Vines

Fancy

Hearts, Dots & Dashes

Doodling is Thinking! • 21 Doodle Days • A Visual Learning Workbook

LESSON 06

Doodling is Thinking! • 21 Doodle Days • A Visual Learning Workbook

#21DoodleDays
with Diane Bleck

PATTERNS

Polka Dot

Double Dots

Scales

Lined Scales

Double Scales

Dual Diagonal

Dual Lines

Vines

Radial Corner

Striped V's

Plaid

Double Plaid

Leaves

Little Dots

Wavy

Weave

Doodling is Thinking! • 21 Doodle Days • A Visual Learning Workbook

LESSON 07

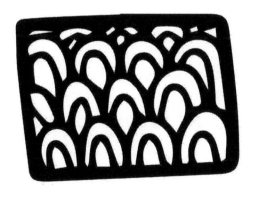

Doodling is Thinking! • 21 Doodle Days • A Visual Learning Workbook

ARROWS

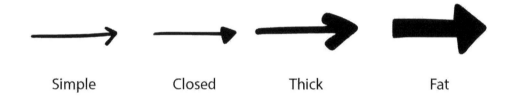

Simple Closed Thick Fat

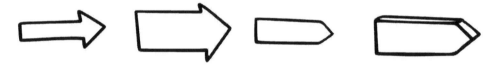

Block Big Block Pointed Pointed Block

Dotted Striped Block Ring Ring

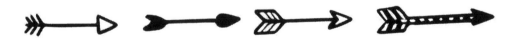

Fancy 1 Fancy 2 Fancy 3 Fancy 4

Doodling is Thinking! • 21 Doodle Days • A Visual Learning Workbook

LESSON 08

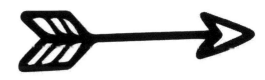

LETTERS

ABCDEFGHIJKLMNOPQRSTUVWXYZ
Upper Case

abcdefghijklmnopqrstuvwxyz
Cursive

ABCDEFGHIJKLMNOPQ
Thin

ABCDEFGHIJK
Thick

Block

Doodling is Thinking! • 21 Doodle Days • A Visual Learning Workbook

LESSON 09

Doodling is Thinking! • 21 Doodle Days • A Visual Learning Workbook

#21DoodleDays
with Diane Bleck

NUMBERS

1 2 3 4 5 6 7 8 9

Doodling is Thinking! • 21 Doodle Days • A Visual Learning Workbook

LESSON 10

1 2 3

Doodling is Thinking! • 21 Doodle Days • A Visual Learning Workbook

#21DoodleDays
with Diane Bleck

FONTS

BOLD SMALL

Fancy THIN

DOUBLE BLOCK

BUBBLE

Doodling is Thinking! • 21 Doodle Days • A Visual Learning Workbook

LESSON 11

Fancy

Doodling is Thinking! • 21 Doodle Days • A Visual Learning Workbook

BANNERS

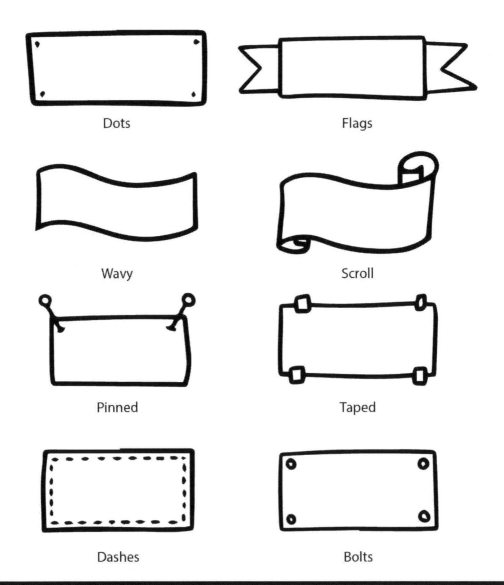

Dots • Flags • Wavy • Scroll • Pinned • Taped • Dashes • Bolts

Doodling is Thinking! • 21 Doodle Days • A Visual Learning Workbook

Doodling is Thinking! • 21 Doodle Days • A Visual Learning Workbook

#21DoodleDays
with Diane Bleck

BUBBLES

Oval Rounded Rectangle

 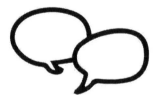

Thought Agreement Dual

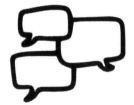

Triple Multi Puzzle

Doodling is Thinking! • 21 Doodle Days • A Visual Learning Workbook

SIGNS

Yard · Staked · Sign Post

Lighted · Arrow · Round

Doodling is Thinking! • 21 Doodle Days • A Visual Learning Workbook

HOW TO DRAW A FACE

Eyes

Nose

Smile

Eyebrows

Ears

Hair

Doodling is Thinking! • 21 Doodle Days • A Visual Learning Workbook

LESSON 15

Doodling is Thinking! • 21 Doodle Days • A Visual Learning Workbook

#21DoodleDays
with Diane Bleck

SHAPES OF FACES

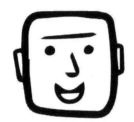

Square Oval Apple

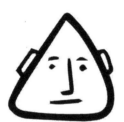 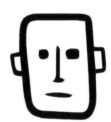

Triangle Pear Rectangle

Heart Eight Round

Doodling is Thinking! • 21 Doodle Days • A Visual Learning Workbook

LESSON 16

Doodling is Thinking! • 21 Doodle Days • A Visual Learning Workbook

EXPRESSIONS

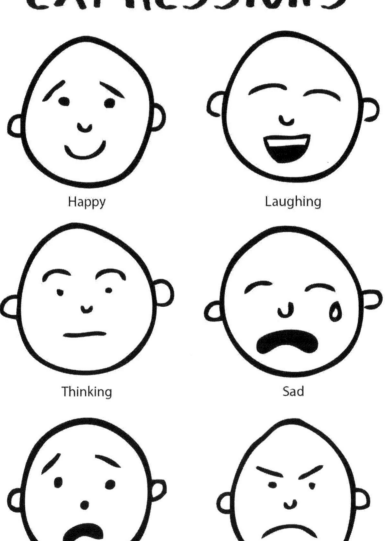

Happy • Laughing • Thinking • Sad • Worried • Mad

Doodling is Thinking! • 21 Doodle Days • A Visual Learning Workbook

Doodling is Thinking! • 21 Doodle Days • A Visual Learning Workbook

HAIRSTYLES

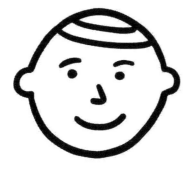

Short Hair

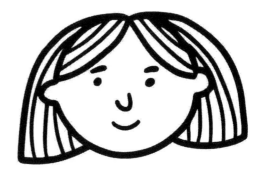

Long Hair

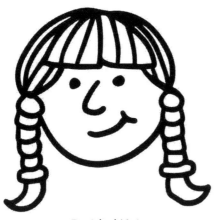

Braided Hair

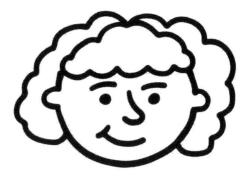

Curly Hair

Doodling is Thinking! • 21 Doodle Days • A Visual Learning Workbook

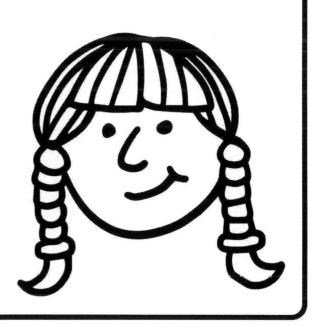

Doodling is Thinking! • 21 Doodle Days • A Visual Learning Workbook

#21DoodleDays
with Diane Bleck

PERSONALITY

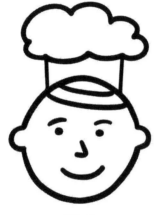
Chef

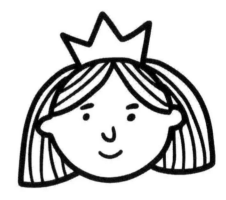
Princess

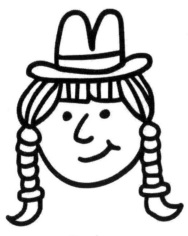
Cowboy

Explorer

Doodling is Thinking! • 21 Doodle Days • A Visual Learning Workbook

LESSON 19

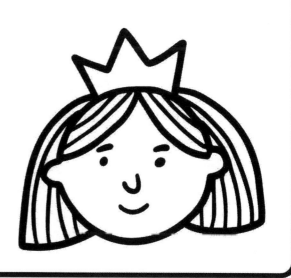

Doodling is Thinking! • 21 Doodle Days • A Visual Learning Workbook

BEAN PEOPLE

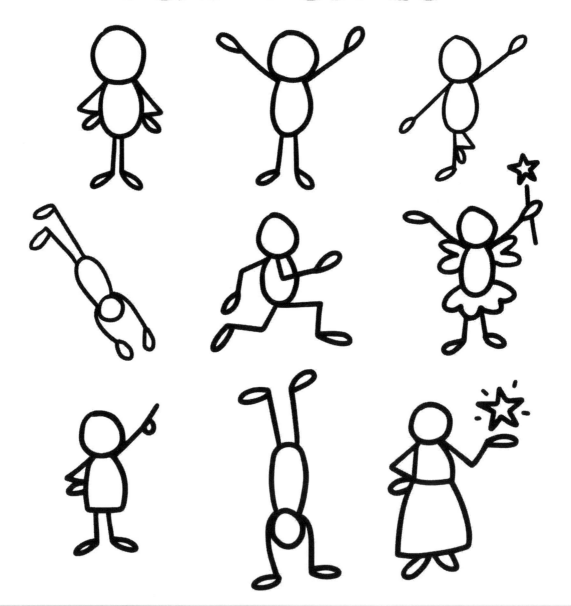

Doodling is Thinking! • 21 Doodle Days • A Visual Learning Workbook

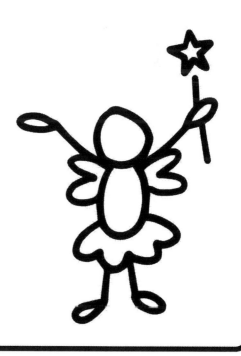

Doodling is Thinking! • 21 Doodle Days • A Visual Learning Workbook

STAR PEOPLE

Circle + Star

Rockstar

Preach

Teach

Together

Around

Group

Talk

Private Lesson

Class

Presenting

Meeting

This Way

Success

Journey

Superstar

Doodling is Thinking! • 21 Doodle Days • A Visual Learning Workbook

LESSON 21

Doodling is Thinking! • 21 Doodle Days • A Visual Learning Workbook

You Were Born to Doodle

Although the word "doodling" still causes much confusion, today the history of doodling is a lot clearer than it once was. Doodling, as we know, is a quick and simple drawing. For years people have associated doodling with not paying attention. And yet, if we look at the cave walls specifically petroglyphs (rock carvings), we will see that the human race has been trying to record our history since the beginning of time.

Doodling is far more than drawing on a scratch of paper. Indeed, doodling has a much richer history than the absent-minded definition that it receives today. Given that from our earliest childhood moments we want to try and scribble on something using an object, it shows that we have a natural affinity for showing the creativity that is stored within our minds.

And I believe that our journals, whiteboards and sketchbooks are just that - a portal to the creative world, for accessing our highest purpose. I have been on a mission to educate parents, teachers and kids that "Doodling is Thinking!"

My hope and life work has been to transform the word doodle into D.O.O.D.L.E

DISCOVER OUR OWN DIVINE LIFE EVERYDAY
I PROMISE YOU, CAN NOT PRACTICE ENOUGH!

Doodling is Thinking! • 21 Doodle Days • A Visual Learning Workbook

Da Vinci was a Doodler

What we call the "da Vinci influence" on doodling is very marked and easy to tell. Leonardo da Vinci is one of the most celebrated experts of all time, drawing everything from his own crazy inventions to life drawings of the fetus within a woman's womb. Over the years, the secret to unlocking his genius has come directly from looking at masses of his doodles.

When we sketch or doodle, we find ourselves in a place of heightened consciousness. You become more active, more capable and more productive. What was at one stage a brutally challenging image to try and conjure becomes easier. Inventing something new that is truly your own creation becomes an easier task when you are doodling - it's also what many of us know as being "in the zone".

Thanks to people like da Vinci, we can see the immense power that doodling has on the end result of any product.

Since people have noticed the immense correlation between creativity and artistic success, with allowing the creative process to go through mass doodling, it's not stopped. From the little inspirational doodle that Google puts on its home page to mark major events, celebrations and dates, to the multitude of apps and games out there with doodling functions, it's a major part of life today.

Doodling is all about being able to spot the limitations in your thoughts today, to help you find the right answer tomorrow. All good inventions and ideas have gone through extensive creative moderation, allowing for the most gifted people to make their ideas come to life.

Without a period of doodling, an idea cannot get through its own bumps and limitations. So, the next time that you try to work through an idea, pick up a pen and a pad- you might just find the perfect solution through doodling.

Doodling is Thinking! • 21 Doodle Days • A Visual Learning Workbook

5 BIG Benefits of Being a Doodler

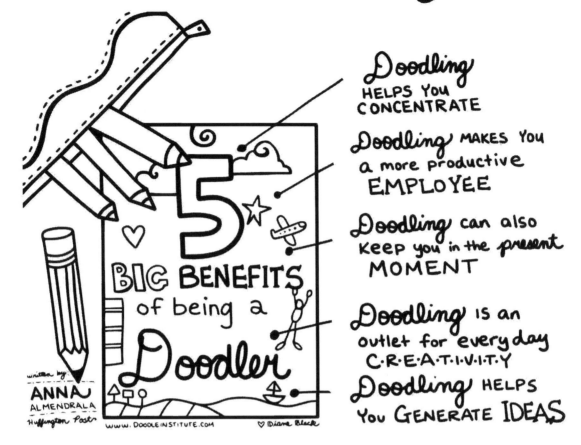

This is an Infographic based on article by Anna Almendralia - she starts by defining doodling.

Doodling — the spontaneous act of drawing, typically in the margins of whatever one is really supposed to be working on — is more than a humble distraction. While doodling gets a bad rap, it's actually associated with better learning, creativity and performance.

What I loved about this article was that it was simple and to the point, and reinforced everything I have been trying to tell clients for years. I am so glad for the doodle, coloring book and graphic recorder movement. The world needs more people who understand Doodling is Thinking!

5 Benefits of Being a Doodler!

1. Doodling Helps You Concentrate
2. Doodling Makes You A More Productive Employee
3. Doodling Can Also Keep You In The Present Moment
4. Doodling Is An Outlet For Every Day Creativity
5. Doodling Helps You Generate Ideas

Read the Article: http://www.huffingtonpost.com/2015/06/17/doodling-benefits_n_7572182.html

HAVE YOU EVER BEEN ASKED, "WHY ARE YOU DOODLING?"

Doodling is Thinking! • 21 Doodle Days • A Visual Learning Workbook

The Powerful Mind of a Doodler

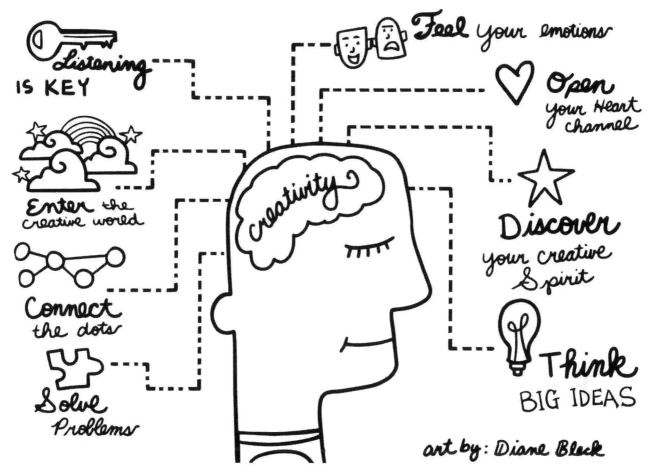

art by: Diane Bleck

More than anything, doodling is a mindset. When we look at famous visual thinkers throughout history and in modern times, we see they share some similarities.

Who are some visual thinkers that you admire? Perhaps Albert Einstein, Thomas Edison, Leonardo da Vinci, Nikola Tesla, Buckminster Fuller, Frank Lloyd Wright and Pablo Picasso? What are some of their shared characteristics? They are curious, brave, courageous, open to feedback, not afraid of failure, detail oriented, and you might even say, willing to color outside the lines.

Good graphic recorders take time to understand their mindset and understand that what they think about themselves and the group matters. They are able to sense team dynamics, to understand what is being said as well as not said by the group.

You are being invited to the event to lend your creative heart and talent, and therefore you must be Willing to Dream. Conversations may not be linear so you will be asked to listen to many vantage points and connect the dots to help groups solve problems.

One of the very important skills that took me a while to learn was the ability to listen to a large group conversation, and also to have empathy. When you understand the group's intentions it is easy to see where they are trying to go in the long run.

Doodling is Thinking! • 21 Doodle Days • A Visual Learning Workbook

The Mutiple Intelligences

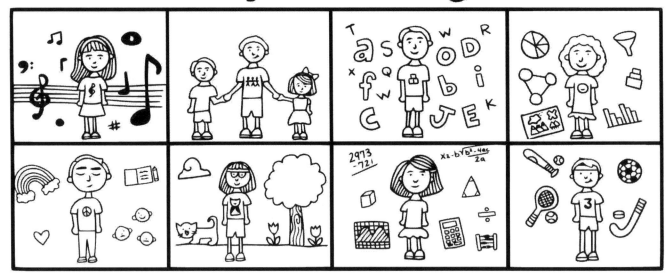

We all know that each person has different strengths, abilities and skills. I was first introduced to the concept of "multiple intelligences" when I read Howard Garner's book on the subject. I finally found a way to explain why I felt like I learned differently to other people. And why journaling was such an important aspect of my life.

When I was growing up the traditional schooling methods basically focused on linguistic and logical learning, with a limited range of teaching techniques to embrace and encourage visual learners. In fact, I remember being told to, "Stop doodling and pay attention!".
What my teachers did not understand is that the doodling was embracing many of my learning styles.

The eight learning styles as explained by Howard Garner in his book Multiple Intelligences:

Visual: When a student prefers using pictures, images for learning and understanding.
Audio: When a student prefers using the sound and music for learning and understanding.
Verbal: When a student prefers using words, both in speech and writing.
Kinesthetic: When a student prefers using his body, hands and sense of touch.
Logical: When a student prefers using the logical and mathematical systems for learning.
Interpersonal: When you prefer to learn in groups or with other people instead of alone.
Intrapersonal: When you prefer to work alone and use self-study.
Naturalistic: When you learn best by studying nature and the environments around you.

Nowadays the educational process involves many new strategies, and the old styles have changed. We might wonder why is it important to identify the notion of individualized learning styles? But it is really important to understand your best learning styles so that you can implement the best practice strategies into your daily activities.

WHICH MULTIPLE INTELIGENCE LEARNING STYLES FITS YOU BEST?

Doodling is Thinking! • 21 Doodle Days • A Visual Learning Workbook

About the Artist

Hi! I'm Diane Bleck and I am on a mission to unlock creativity at home, school and work. My aim is to change the world by inspiring people to discover, dream and doodle.
I have spent my career bringing doodling to businesses, healthcare communities, education programs and families.

The Doodle Institute opened in 2014 with a series of online courses to teach others how to doodle their dreams. Through The Doodle Institute thousands of people just like you have discovered how putting pen to paper opens your heart channel, to beckon in the creative world with access to new ideas, insights and inspiration.

Recently I was invited to teach a doodle course in my daughter's 7th Grade classroom. This has become a yearly tradition for my family. At the end of the class, a student raised their hand and said, "I wish you come into our classroom every day to teach us."

And so I got an idea to build a course that was designed for just that. A series of lessons where I could teach doodling in schools and homes around the world.

After decades of hearing, "I don't know what to draw or I wish I had a tool to get me started." Now you do!

This workbook has been developing over the past 20 years of my doodle practice, and this book was inspired to help you find your creative spark. I invite you to dive in, get messy, start coloring and be part of the magic! Don't let fear stand in your way; color any self-doubt away, and let your dreams shine through. We hope this coloring book will help you take time to connect pen to paper, and in doing so, rediscover your creative spirit.

You're invited to share your creations online and to use the hashtag #DoodleFriends, #DoodlewithDiane or #Doodle Institute so that I can find you and celebrate your creative spirit. We also encourage you to sign up for a free course at: www.DoodleInstitute.com

Made with love,

Doodling is Thinking! • 21 Doodle Days • A Visual Learning Workbook

21 Doodle DAYS

Sign Up for a FREE Online Course TODAY!!

The Doodle Institute offers over 100 Videos & 40+ Creative Exercises with over 2,325 students enrolled from around the World!

OBJECTIVES:
Upon completion of these courses, students will be able to:

- **Understand** the basics of drawing and color theory
- **Increase** your confidence in your ability to doodle
- **Acquire** a visual vocabulary
- **Tap** their hidden pool of creativity
- Use visual tools to create richer learning environments
- **Enrich** group conversations and create better understanding
- **Add** meaning to meetings
- **Map** conversations
- **Design** numerous applications for doodling for business, education and families
- **Apply** your new skills to your own career path
- **Design** breakthrough moments

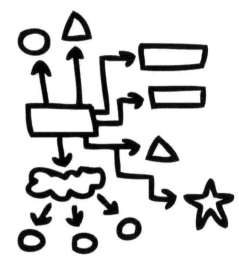

BENEFITS:
- **Engage** in a new way of learning
- **Boost** your creativity
- **Enhance** your ability to simplify complex concepts
- **Increase** idea generation
- **Accelerate** understanding
- **Expand** your toolkit of products and services

Doodling is Thinking! • 21 Doodle Days • A Visual Learning Workbook

Doodling is Thinking! • 21 Doodle Days • A Visual Learning Workbook

Doodling is Thinking! • 21 Doodle Days • A Visual Learning Workbook

Doodling is Thinking! • 21 Doodle Days • A Visual Learning Workbook

Doodling is Thinking! • 21 Doodle Days • A Visual Learning Workbook

Doodling is Thinking! • 21 Doodle Days • A Visual Learning Workbook

Made in the USA
San Bernardino, CA
15 May 2019